MARTHA MITCHELL OF POSSUM WALK ROAD

Texas Quiltmaker

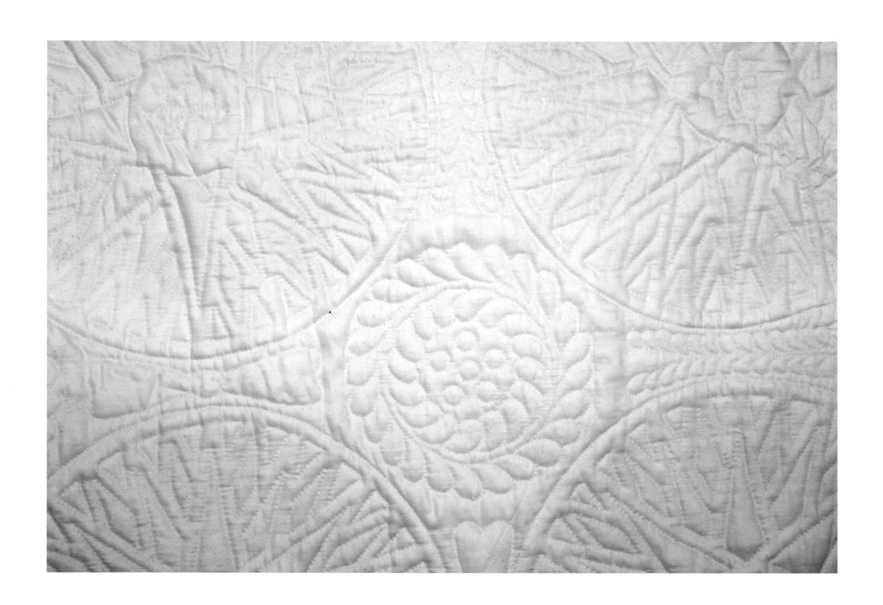

MARTHA MITCHELL OF POSSUM WALK ROAD

Texas Quiltmaker

TEXT BY
Melvin Rosser Mason

PHOTOGRAPHS BY
Westen McCoy

TEXAS REVIEW PRESS, HUNTSVILLE, TEXAS

For Davenport,
Susan Davenport,
an excellent quilter herself
Melvin R. Mason
November 23, 2002

Life is a Patchwork!

The paper used in this book meets the minimum requirements
of the American National Standard for Permanence
of Paper for Printed Library Materials, Z39.48-1984.
Binding materials have been chosen for durability.

Front cover: "Old House and Quilts," painting by Martha Mitchell.
Proceeding page: "Mariner's Compass" lining.
Forward page: Martha Mitchell holding "Turkey Tracks."

Cover and interior design by Joan E. Osth

Library of Congress Cataloging-in-Publication Data

Mason, Melvin Rosser, 1927-

 Martha Mitchell of Possum Walk Road: Texas quiltmaker / text
by Melvin Rosser Mason; photographs by Westen McCoy. — 1st ed.

 p. cm.

 ISBN 1-881515-22-2 (cloth)

 1. Martha Mitchell, 1902-1985. 2. Quiltmakers—Texas Biography.
3. Quilts—Texas—History—20th century. I. Title

 NK9198.M57 M38 1999

 99-39376
 CIP

✷

This book is dedicated to the memory of my wife,
Mayenell Waterman Mason
1928–1994

One time my brother told me a person would have to be crazy to take large pieces of cloth, cut them up into little pieces, and then sew them back together again.

MARTHA MITCHELL

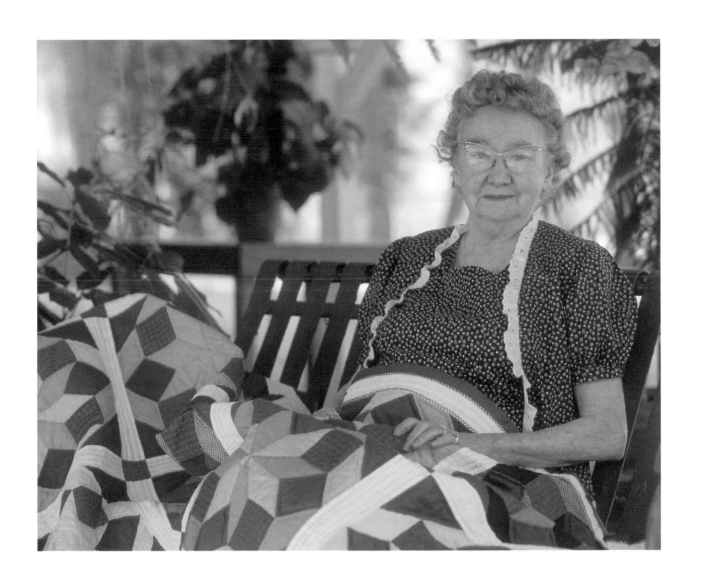

CONTENTS

WORKING WITH MARTHA MITCHELL

A Reminiscence

From 1981 until her death in 1985, I worked with Martha Mitchell on a variety of creative projects related to her art. Although she is more widely known for her quiltmaking, Martha also painted in oils and wrote verse, and she was admired for her quick wit as much as for her folk art. With her help, I made a slide presentation for the Texas Folklore Society's meeting in Fredericksburg in 1982, with Martha doing the taped narration to which we added background music arranged and performed by Jan Cole. Most of the photography was done by Westen McCoy of the Sam Houston Press. Martha was a primary source for a chapter on quiltmaking that I wrote for the book *Folk Art in Texas*, published by the Society, and she and I made a joint presentation for a TFS meeting in College Station. I learned early on that we received our best response from audiences when she talked more and I talked less. Our production to gain the most public notice was the documentary released for public television in 1985, *Martha Mitchell of Possum Walk Road: Quiltmaker*, and shown all over the country on PBS stations. It is still available on videotape.

With Martha, there was always a new surprise. During the years that we worked together, we presented programs for a variety of organizations: East Texas Historical Association, American Studies Association of Texas, AARP—and our last, in October, 1984, before her death the following January, was for the American Folklore Society in San Diego. While we were there, we made a short day trip to Tijuana, since she had never been to Mexico, and another day we visited the San Diego Zoo, where we started by visiting the Koala bears and ended up riding the elephant. Martha's adventuresome antics should have been no surprise to me. I knew that she rode horseback as a girl, and she was still riding her lawnmower and doing yard work at the age of eighty-two. That day, though, she was dressed as "little old ladies" are expected to look—with sensible shoes, dotted swiss dress, and grey hair—so she cracked up our audience when she climbed the platform and hopped astride the elephant with me. The elephant handler stopped the elephant, posed, and our friend Sylvia Grider snapped the picture!

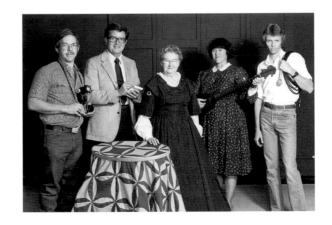

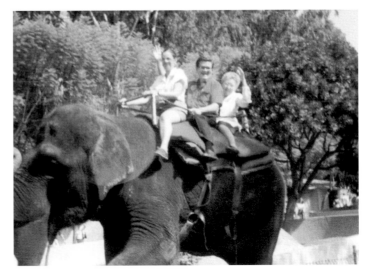

The crew for the slide show: Westen McCoy, photographer; Melvin Mason, producer; Martha Mitchell; Jan Cole, musician; Bill Patrick, sound engineer.

San Diego, 1984

San Diego was also the scene for Martha's first—and as far as I know, her last—experience with *booze*. She had told me once, "You know, in all my life I have never tasted wine or liquor. Sometime when we're off away from here on one of our trips, and none of these Huntsville people are around, I'd like to try some of that wine." Well, the main banquet for the American Folklore Society in San Diego was an elaborate Mexican buffet, and each guest was provided a huge dinner plate. Martha had a throat condition that made it easy for her to choke, so she habitually ate only simple, bland foods in public. After going through the food line, I noticed that she had only small dabs of the different Mexican dishes arranged on her plate. On the dining tables

were pitchers of Sangria, so she decided that this would be the occasion for her introduction to the delights of alcoholic beverage. While she politely picked at the food on the plate, she sampled a tablespoonful of the Sangria and observed confidentially that it was something of a disappointment. So she returned to Huntsville without having been led too far astray.

I must confess that I am responsible for leading Martha Mitchell to more than strong drink. At our TFS meeting in Fredericksburg, I asked her to dance. She was widowed, and I did not know that she had not been on a dance floor for sixty-two years. She had enjoyed dances in her youth, but she gave it all up when, at the age of 18, she married Edward P. Mitchell, back in their home state of Kentucky. After our Fredericksburg experience, Martha took professional lessons to brush up her skills and enjoyed dates with other men for dances sponsored by the Walker County Fair Association.

In earlier years, the Smithsonian Institution had asked Martha to donate one of her quilts. At the time, she declined, because she had nothing to give. Her interest in a quilt waned once she completed it, so it usually went to a relative or to the person who commissioned it. In 1984, Martha, my wife Mayenell and I visited Washington D.C. for a folklife festival. We were not able to see many quilts, because most were in storage, and our friends in high places were too busy with the festival to give a special tour. We had not known that we should make arrangements in advance. "Well," Martha said, "I'm glad now that I didn't give them one of my quilts. They would have it locked up and nobody could see it."

As she had hoped, Martha remained physically active until the day of her fatal heart attack. Dying just as our documentary was about to be released, she was not with me for our planned lecture tour in her native state of Kentucky. We had appreciative audiences at the state University in Bowling Green, and in her hometowns of Cadiz and Henderson, where I placed a yellow rose on her grave. Both son DuWayne and husband Edward had preceded her in death. I am always glad that our work together brightened her own last years.

When we made our slide show, Martha tape-recorded the narration. At the end, she said, "And one thing more. When you start growing old, you better keep doing something that's interesting to other people. If you don't, they'll sure forget you!" I keep that in mind.

M. R. M.

Huntsville, Texas

November 30, 1998

ACKNOWLEDGMENTS

Many people have helped in our projects related to Martha Mitchell.

Kay Turner of Austin, professional folklorist and author, invited me to prepare an extended essay to be included in an anthology of Texas folk artists. She skillfully edited my manuscript and contributed information, adding the commentary on quilts by African American and Coushatta women. Although the proposed anthology was not published, much of the material that Kay collected and edited achieved publication in other forms. So there are many of us who are indebted to her.

Later, Sylvia Ann Grider, a past president of both the Texas Folklore Society and the American Folklore Society, and professor of folklore in the Texas A&M Anthropology Department, read the manuscript and made needed suggestions.

Finally, Beth Miles of Sam Houston State's Office of University Advancement made valuable suggestions, drawing on her personal knowledge of sewing.

Earlier, Pat Jasper, now director of Texas Folklife Resources, suggested our documentary for public television while she was on the staff of the Texas Commission for the Arts. D Matteson Pascal of Meadows Foundation responded to our request for financial help at a critical time in the development of the documentary, as did the Huntsville Arts Commission, Texas Commission for the Arts, Bill and Martha Taylor, LuEllen Gibbs, Kenneth and Marjorie Russell, and Samuella Palmer.

Mrs. Mitchell's unique personality attracted people who gave of their creative talents beyond measure. Westen McCoy of Sam Houston Press shot photos used in our original slide presentations, included in the documentary, and finally appearing as illustrations in this book. Jan Cole, Huntsville resident formerly of the University music faculty, composed original music and adapted traditional tunes for her performance on a variety of folk instruments, providing background for both slide presentation and documentary. On the staff of Texas A&M's KAMU-TV, Dick Rizzo and Jack Peterson, both directors, gave me the support needed as a novice producer.

Recognition is also due the many who loaned quilts, helped with exhibits, and contributed in other ways: Mr. and Mrs. Lowell Mayrant, Mr. and Mrs. John Grissom, Commander and Mrs. N. E. Black, Dr. and Mrs. Steve Black, Dr. and Mrs. Eddie Dye, Mrs. Elly Choate, Mr. and Mrs. Lewis Hillman, Mrs. Alibee Rogers, Ann Fears Crawford, Linda Pease, Jane Anderson, and the staffs of Huntsville Public Library, Sam Houston Memorial Museum, and Huntsville Arts Commission.

Members of the University's administration and staff have given encouragement and help. Among others, these include James DeShaw, Steve Montgomery, Richard Cording, James Goodwin, E. Rex Isham, Beth

Miles, LaNell Albritton, Iola Fulgham, and Frank Krystyniak. Karey Patterson Bresenhan, a distinguished alumna of Sam Houston State University, has in part subsidized publication of this book with a generous cash gift to the University and has been helpful in many other ways.

The book is my gift to the University. Any profit will be divided among the Martha Mitchell scholarship fund, Sam Houston Memorial Museum, and *Texas Review* Press. The Press and the Museum have invested their resources in publication and promotion. I am indebted to Paul Ruffin, Director of *Texas Review* Press, and to Joan E. Osth, who created the design for this book.

Many others have helped, but I shall not attempt to list them, risking missing someone. These included Martha's relatives in Kentucky, who helped with the Kentucky lecture tour, and her relatives here in Texas, especially the grandchildren. A diverse group, we are all related by our love and admiration for the grand lady we shall never forget.

M. R. M.

Huntsville, Texas

April 20, 1999

MARTHA MITCHELL OF POSSUM WALK ROAD

MARTHA MITCHELL OF POSSUM WALK ROAD

Texas Quiltmaker

*Quilting is like a melody. There's a rhythm to the stitches—waves and tempo. Take four or five stitches on the needle at a time, ten stitches to the inch. You have to catch that rhythm Maybe it's a talent, a gift I have and I'm supposed to keep on doing it. If you ever stop, if you quit using that gift, it will be taken away from you. So I won't ever stop—I'll just keel over.—*Martha Mitchell

Until her death in 1985 Martha Mitchell lived on the outskirts of Huntsville, Texas, on Montgomery Road.

It used to be called Possum Walk, but after we got annexed into the city, they probably thought that wasn't dignified enough to name a city street, so they changed it It's still called "Possum Walk," though.

After the death of her husband in early 1982, Mrs. Mitchell continued to live in the white frame house they built on wooded acreage bought in 1939 when they and their young son moved from Kentucky seeking a milder climate because of Mr. Mitchell's poor health. Martha had been willing to come, for it had been difficult for her to find profitable work in Kentucky, despite her training and civil service qualifications.

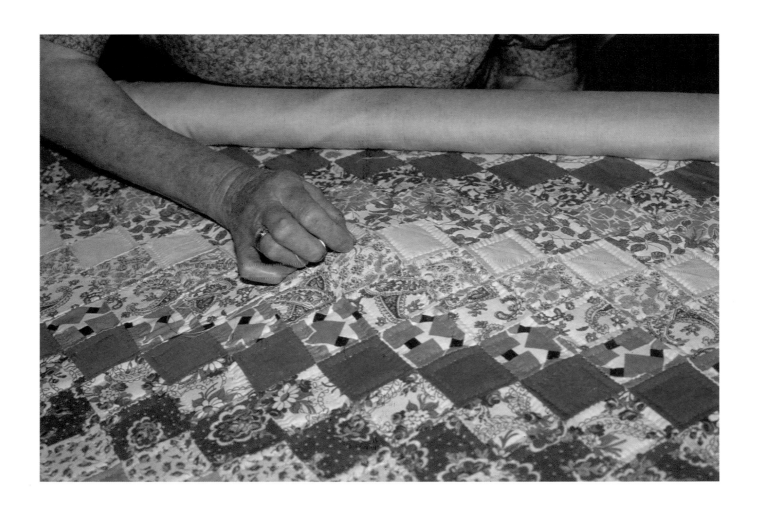

The openings there—especially in the post office—were for men. They hadn't accepted women as workers, and so it was hard for me to get any type of work that paid off up there. The traditions were settled, and they didn't like women workers much, except for school teachers, and I didn't want to teach school. So I was willing to come to Texas, and as soon as I got here I went right to work, and I worked for thirty-three years.

A rustic sign near the mailbox at the entrance to her home announced "The Mitchell Diggin's" with the subtitle "Shadowlawn."

That's a strange, name to have for a place, but when we bought that in 1939 it was way out in the country, just a natural forest with dead logs, vines growing all over the trees, and we dug it out verily by the roots.

A self-taught painter, Mrs. Mitchell worked in oils for years as a hobby, but she became increasingly well-known for the fine quilts that she produced. She was one of three featured artists in the "Patterns in Patchwork" exhibition at Sam Houston Memorial Museum in Huntsville in 1982, and was the subject of an audiovisual presentation, "Martha Mitchell of Possum Walk Road: Artist with Needle and Brush," prepared for the Texas Folklore Society.

Martha Mitchell's quilting art is firmly rooted in the folk tradition. As a child in Kentucky, she learned the basic skills of quiltmaking from her mother. In the years that followed, she completed more than a hundred handmade quilts, working with traditional folk patterns, but also exercising her own creativity in modifications that often resulted in a more complex and sophisticated art.

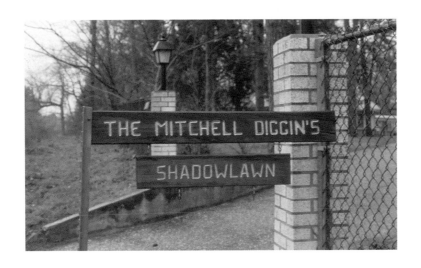

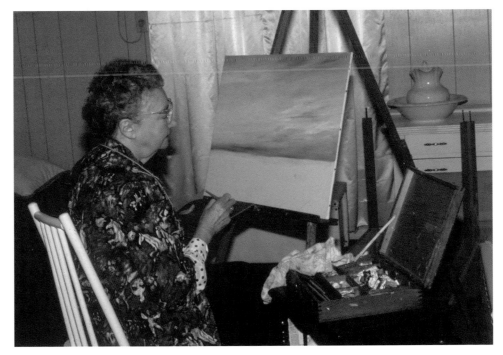

Quilts are warm because of all of the love that's stitched into them My brother told me one time that a person would have to be crazy to take big pieces of cloth, cut them up into little pieces and then sew them back together again I made my first quilt when I was nine years old

The patchwork quilt is an art form born of necessity, and it flourished in early America because of the need to save and use every scrap of cloth to produce warm bedcovers. Some quilts are rather crude and strictly utilitarian, consisting of top, lining, and batting merely tacked in some way to hold the three layers together. From the beginning, though, there were women who made their quilts as attractive as they could within the limitations of available materials. Quiltmaking, a very useful, practical, necessary activity, could also become a vehicle for artistic self-expression.

In fact, quilting is one of the most individually expressive of all the traditional arts. According to the 1982 book *Feminism and Art History,* by Patricia Mainardi, " . . . the women who made quilts knew and valued what they were doing: frequently quilts were signed and dated by the maker, listed in her will with specific instructions as to who should inherit them, and treated with all the care that a fine piece of art deserves." Women proudly showed their quilts at home and in local and state fairs. A good quilter had status and enjoyed a degree of celebrity in her community. Women made, and still make, quilts as a personal expressive outlet and to display their individual talents.

TEXAS QUILTERS

In Texas, quiltmaking has been a primary artistic vocation of women since Anglo settlement first began. Texas women have adapted an old and widely practiced American art to their own needs and circumstances. They brought quilting patterns West with them, but they changed the design names to fit their new surroundings. For example, a pattern called "Star of Bethlehem" in late eighteenth century England and Colonial America has become the six-pointed "Lone Star" in Texas.

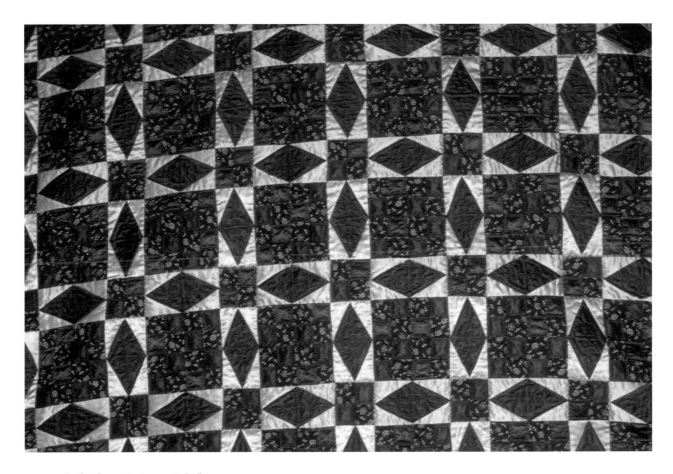

"Fifty-four, Forty, or Fight"

Generally, Western quilting is characterized by the piecing as opposed to the applique technique, but Texas quilting is further distinguished by being a cross-ethnic art. Here, the tradition is elaborated and enriched through ethnic and regional distinctions: the strip quilts of Afro-American women contrast with the wool-battened, colorfully blocked quilts of South Texas Mexican-American women, and these, in turn, are different from the fan or tulip designs East Texas Coushatta Indian women learned to make from their white neighbors. Different Texas women quilt for different reasons. Outside San Angelo a widow who lives on an isolated ranch may quilt as an antidote to loneliness while at the Lytton Springs quilting bees women have enjoyed the social relations of this art over many years. The regional, ethnic, and individual distinctions of Texas quilters define an art form in which can be read the legacy of women who have maintained an informal, but no less potent, means of preserving their familial and communal heritage while at the same time promoting their personal creativity and self-esteem. As Cooper and Buferd suggest in their 1977 book on Texas and New Mexico quilters, *The Quilters: Women and Domestic Art*, "The pioneer home must have been a particularly challenging place for inventive design under the pressure of necessity."

Although Texas quilters today usually do not practice their art out of imposed necessity, perhaps one West Texas woman expressed the sentiments of many when she said in *The Quilters*, "You can't always change things. Sometimes you don't have no control over the way things go. [But with piecing] the way you put them together is your business. You can put then in any order you like. Piecing is orderly."

Quilting is a way of gaining control and esteem through self-assertive creativity. When Texas mothers teach their daughters to quilt, they teach them values and virtues as well as techniques and pat-

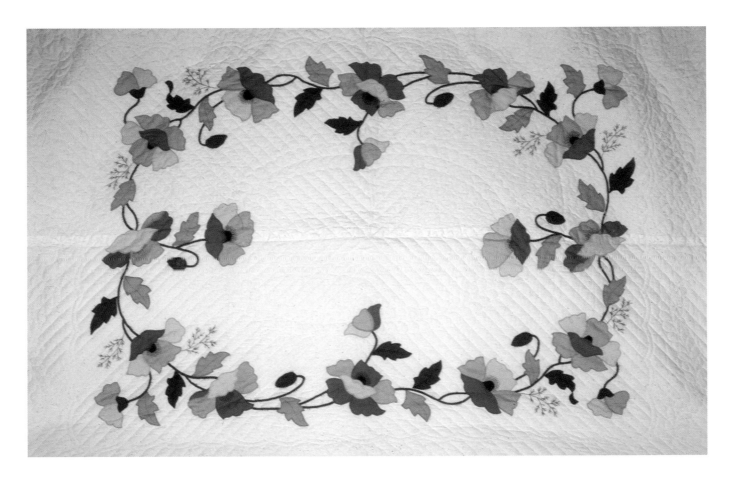

"Tulip" applique

terns. And they give them an artistic option for self-expression, something that rarely fails even when other things do.

THE TENSION BETWEEN FREEDOM AND NECESSITY

Martha Mitchell stitched her first quilt when she was nine years old. Her introduction to quiltmaking was not a matter of choice: It was required of her by her mother, a woman of Welsh descent who trained all of her daughters in traditional domestic skills. Through the years, the work that began as a requirement imposed on Martha in childhood became a labor of love, and later in life she made quilts not of necessity, but by choice.

A tension between freedom and necessity is inherent in the actual process of quiltmaking, and that tension is especially evident in Martha Mitchell's work. She never invented a totally new patchwork pattern, always working with traditional ones. Even so, she constantly found ways to make a quilt uniquely her own. In addition to modifying traditional patchwork patterns, colors, and materials, she created new borders to "frame" her quilts, and she invented new quilting designs to fit into the open spaces of the patchwork tops, embellishing them with elaborate displays of stitchery. So, working within the restraints of tradition, she was still able to produce quilts that exhibit tremendous creativity and freedom of personal expression. For example, one hardly realizes that the basic pattern of her dazzling "Blazing Star," made of gold and white satin, is after all, the simple "Eight-Point Star."

At age eighty-one, Martha Mitchell kept up a lively pace. In addition to quiltmaking and painting, she designed and sewed most of her clothing and did all of her own housework. She maintained

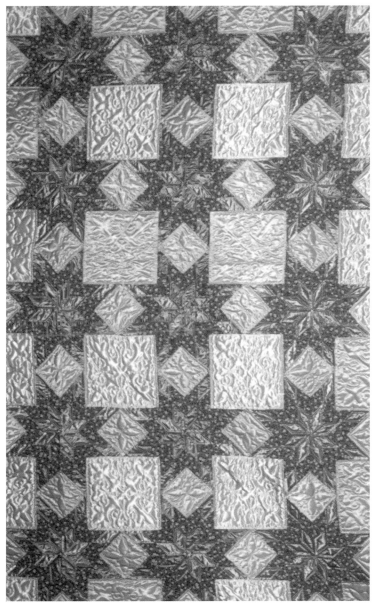

"Blazing Star" is Martha's own
adaptation of the the simple
"Eight-Point Star" pattern.

the grounds with a riding lawnmower and cared for more than a hundred potted plants and hanging baskets that surrounded her patio in good weather and spent the winter in her greenhouse. She drove her faithful 1971 Toyota for local errands, presented programs on her quilting, and traveled with the American Association of Retired Persons and other groups. As a widow in her late seventies, she took a series of dancing lessons from a friend, brushing up on an interest that she had not pursued since she married.

Long accustomed to frugal living, she allowed herself a few luxuries after her husband's death. She made a trip to Halifax and Niagara Falls, and she talked of plans for a Caribbean cruise and a visit to Hawaii. Even so, she handled her money with care. When she was the guest of a local art league, she appeared in a two-piece costume fashioned of black velvet and white crepe, discreetly accented with an appliqued floral design across the front. The audience was aware that she designed it herself, but they did not know that she put it together with materials from Wal-Mart for $11.58.

Guests in the neatly kept Mitchell home were surrounded by reminders of the artist's work and mementos of her life. In the combination dining room/work room the ever-present quilting frames held the current project. Scrapbooks contained photographs of completed paintings and of quilts that now belong to friends and collectors across the country. A strong sense of pattern and order prevailed in the Mitchell household; in her surroundings as in her quiltmaking, Martha Mitchell attended to details with the certainty of an artist who loved color and design. One whole wall was covered with carefully arranged rows of salt and pepper shakers, more than 300 sets from all over the world. She bought some of them herself, but most were gifts.

Certain remembrances displayed in her home attested to Mrs. Mitchell's lasting sense of legacy from her family, especially her mother. In nearby bedrooms, quilted wall hangings illustrated traditional

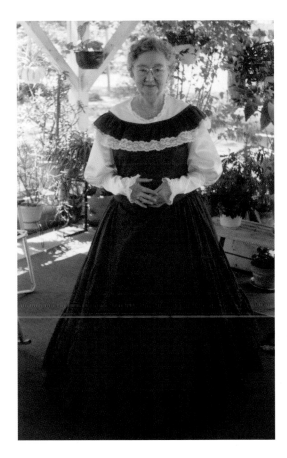

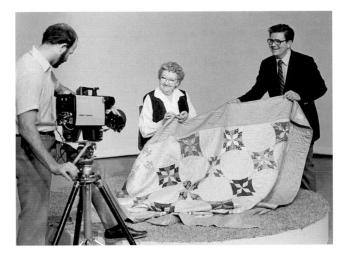

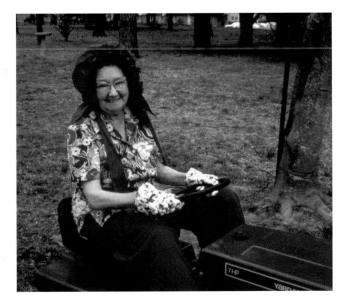

Martha on the patio in a dress of her
own design and construction.

Martha and the author doing promotional
work in the KAMU, television studios.

Martha on her lawn mower.

"Poinsettia" and "Log Cabin" patchwork patterns. A hope chest held stacks of crochet and embroidery work completed before she was married. In the hallway hung a framed fragment of a quilt in the "Flying Geese" pattern, completed by her mother in 1912. "She just made it for cover to sleep under," Mrs. Mitchell said.

It wasn't made for any show or art work at all. But everything that she did, she used her artistic ability to the best that she knew how. A counterpane was always put on top of it; nobody ever saw it after she had it made.

On the living room wall, along with paintings and sketches, hung an intricately detailed family tree, drawn in pen and ink, the roots, trunk, and branches labeled with names of ancestors and relatives. And illustrating Mrs. Mitchell's attitude toward her work, there also appeared a framed sampler that she cross-stitched on linen in 1943, bearing the legend "Every good and perfect gift is from above." "We are all given talents," she said "which we should develop and not hide under a bushel basket."

Mrs. Mitchell viewed her talents as gifts that she was obliged to develop and exercise. *I feel that we are given these talents, and I feel that we should go ahead and use them . . . I think that when we quit whatever we are able to do, it diminishes, and after awhile we get so we don't want to do it. But if we keep on doing it all the time, it grows.*

If this sense of obligation was instilled by family or by religious teachings, she was not aware of it.

It's just something that I feel inside of me that I must keep doing. It's not a religious thing. I don't feel compelled. I just feel urged to do it . . . maybe I feel like it's the only thing that I can do well—the only talent that I have that I feel satisfied that I'm doing pretty well with.

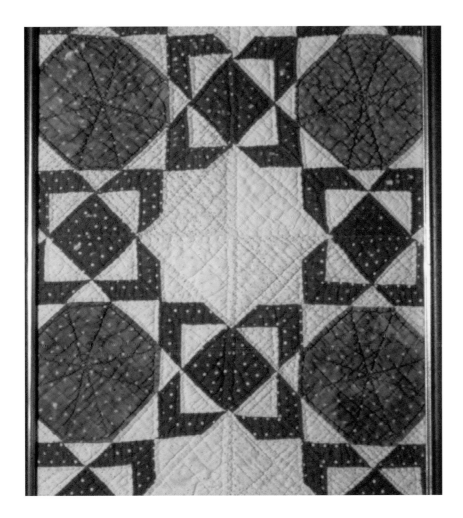

Fragment of a quilt in the "Flying Geese" pattern,
completed by Martha's mother in 1912.

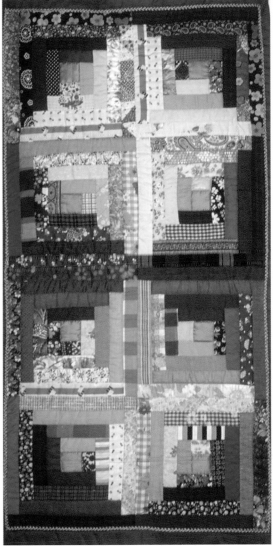

"Log Cabin" wall hanging.

Although Mrs. Mitchell sold her quilts and paintings, she was never actually dependent on them for income, and she valued her "hobbies," as she called them, more as an outlet for personal creativity and as a means of maintaining relationships with other people.

The regular routine of just living, your work, or whatever you might have dropped into, is not enough for a person. You should have some outlet for your personality, for your love and your dreams. That's why some people don't live very long after they quit working. If they don't have a hobby of some sort to keep them going, you will notice so many people, especially menfolks, don't live more than two years after they retire. Because they think they are going to fish, or hunt, or something like that—which is not an outlet for their feelings. It's not something that they can create and put themselves into. So I'm glad that I have kept up my hobby all these years. It is an outlet, and it keeps me in touch with the public, and with people, and I just don't know how I could get along without it. I would probably be over there in the nursing home too.

Quilting was a mark of Mrs. Mitchell's independence, a declaration of her right to create freely.
I like to do what I want to do, and not what somebody tells me to do. Because when somebody starts telling me how they want it done, that takes away the creativity, you know. I want to do it like I want to do it. That's the reason I'd rather start from scratch and build as I go to the finish, rather than to take a copy somebody else has pieced, and all I do is just quilt it.

In a smaller building behind the main house, Mrs. Mitchell arranged a studio where she set up an easel for her painting and where she stored quilting frames and other supplies. A varnished plywood board displayed news clippings and blue prize ribbons. A wooden storage box held fabrics for projects envisioned, yet to be achieved. Her comments on painting are also indicative of her assertive approach to quiltmaking and life in general.

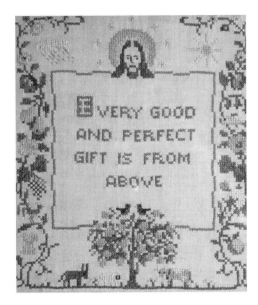

Sampler.

Martha as a young lady out for a ride.

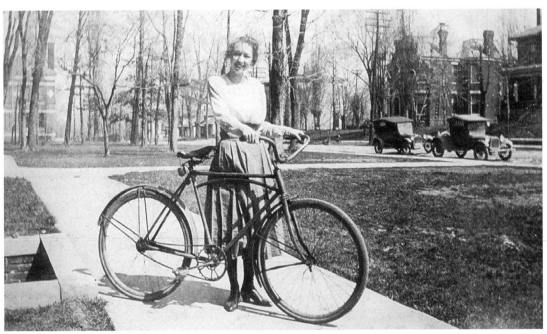

I don't know whether I'm obstinate or contrary, or just don't like to be told things, but when I start out to do something, I want somebody to just let me alone and I build on my own ideas. Sometimes they turn out good, and sometimes they don't. But that's one reason I never did take any art lessons. I think that when one takes art lessons, they tend to be influenced by their teacher's style, and I didn't want to be influenced by anybody's style. I have had people come to me and say, "I saw one of your paintings." Maybe it wasn't even in this town; maybe it was someplace else —"And I knew it was yours before I looked at the name on it." I think that real artists do have their own style. Not that I wanted to have my own style—but I just didn't want anybody to tell me what I should do. I prefer to make my own blunders.

LIFE HISTORY: WOMEN'S REALITIES, WOMEN'S CHOICES

Mrs. Mitchell was proud of her Kentucky heritage. *Most all of these traditions that are now called Texas folklore originated somewhere else. I don't know whether you ought to say that at the Texas Folklore Society, All of these patterns, and my ability to do this was well established before I ever came to Texas.*

Mrs. Mitchell was fond of saying that she had lived "from the manual age to the electronic age." She also lived through tremendous change in attitudes toward women. She grew up and married early in a society in which few women worked outside the home. Then, after seventeen years of marriage she took a business course to learn secretarial skills, passed a civil service examination, and worked at a variety of jobs for thirty-three years. For twenty-three of those she was executive secretary for Sam Houston State University's alumni organization. And she remained married to the same man for sixty-two years, fulfilling the traditional duties of wife and mother. Throughout her marriage, both her professional work outside the home and her artistic endeavors provided a needed balance.

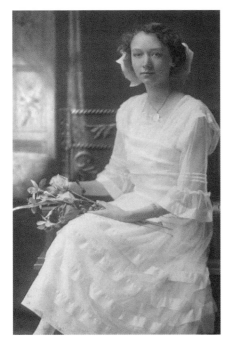

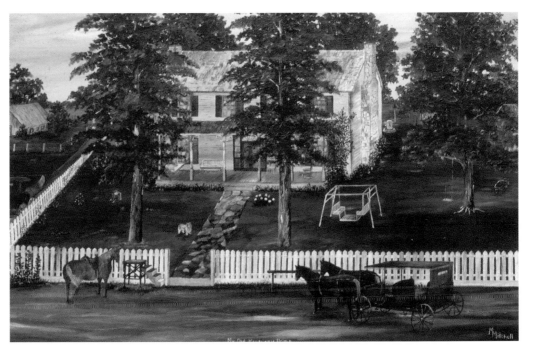

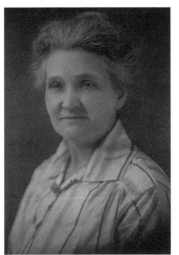

Martha at sixteen.

Martha's painting of her own "Old Kentucky Home."

Martha's mother, Sarah Martin.

Born August 1, 1902, near Cadiz, Kentucky, in Trigg County, she was Martha Alma Martin, the youngest of the four children of Jefferson Davis Martin and Sarah Manthus Martin. Nine years later the family moved to a larger 300-acre farm near Henderson in Henderson County. It was there on the Ohio River that Martha grew up, attending a one-room rural school through the eighth grade and later graduating at age sixteen from Barret Training High School in Henderson, the youngest in her class.

From their earliest years, Sarah Martin taught all her daughters the domestic skills expected of wives and mothers, for there were few opportunities for women outside marriage in Henderson County, Kentucky, in the early 1900s. "I wanted to work in a drug store," Martha remembered.

Now that's a strange desire. All of those beautiful bottles, and the people coming in. They had the soda fountain where everybody gathered And it just seemed to me to be the most exciting thing that anybody could have done, working in a drug store. My mother would never have let me do it, because girls just didn't get out on their own.

So, at the age of eighteen, Martha Martin married Edward P. Mitchell, eight years her senior, a veteran of World War I and a native of Paducah, Kentucky. Marriage was a traumatic change. On the farm, through high school and after, Martha had led a very active social life.

But then, when I got married, that put an end to all of that. I became Mr. Mitchell instead of me. You were trained to do that. The woman's place was in the home. He believed that; he was reared that way. He was older than I was, and it was very exciting to be courted by an older man. He was very handsome, and he had a way with the women, and so I thought, well, that will be all right, because I am trained for that When I was a girl, women couldn't even vote at all. They were just chattel for men to have in their homes, to wait

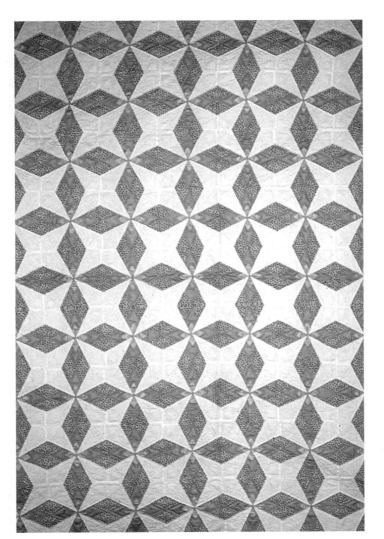

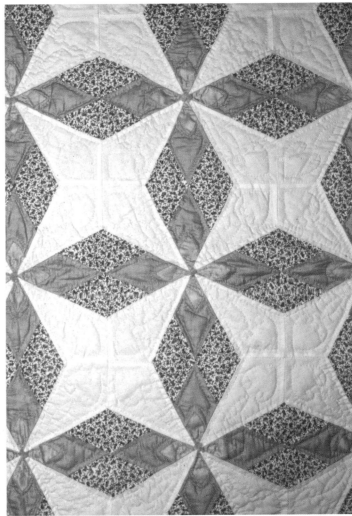

"Hearts and Flowers"

on them, and to bear children. His word was law. If a woman became a widow, and she maybe had a couple of children, or more, there was nothing for her to do except get married to some man. And then, he could take her children and bind them out as servants to somebody else, and she couldn't say a word about it. Sometimes I wonder if this change in me from the traditional to the modern wasn't a bit of a rebellion. I didn't like to be told what to do, though I did, and I think I made Mr. Mitchell very happy as a dutiful wife, but there were times when I absolutely rebelled. I just rebelled against all of this ownership of women. I could take a lot of that out in my hobbies: in my quilting, and in my art work. I expect a lot of other women did that a long time ago, too.

Woman's customary role as the handmaid of her husband could be subtly but satisfactorily subverted through the personal creativity quilting allowed. Their art served as a release from the tedium and constraint of doing what was expected.

When I was a girl my mother made most of my clothes, and she made them with satins, and beautiful materials and pretty colors because she liked those colors too. After I got married, he wanted me to wear something rather somber, as an old married lady would do, and not attract any attention from anybody else. He would say I was making a spectacle out of myself. And so if I had a very colorful dress—which I did not have very often—he did not like it at all. I was just not supposed to wear that out in public. I well remember one time his sister bought a piece of red material and gave it to me, and I said "He won't like that if I make a dress out of it," and she said, "You just go ahead and make a dress out of it and wear it. He has no business telling you to wear those dull clothes like you wear." And so, I did. His sister was a very independent woman herself. He had a whole lot of sisters, and they all realized that he was too strict as a married man. And one time one of the neighbors gave me a dress that had some green in it. I just loved that dress; it was a kind of a taffeta, a pretty material, and I went ahead and made a dress out of that and wore it. And he couldn't say

"Henry Clay's Choice"

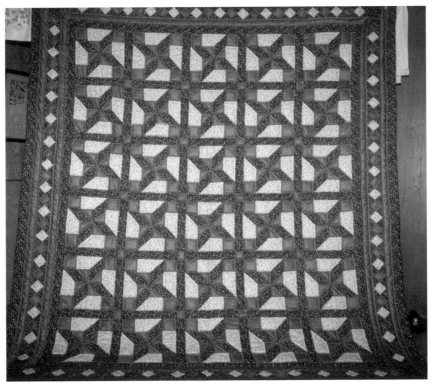

anything about it because it was given to me by the neighbor. But he didn't like for me to wear anything that would attract attention. In fact, one time he said, "If a woman has anything to say in public, she should tell her husband what she has in mind and let him say it." Now that's just carrying it a little bit too far. And all that built up in me, you know.

Quilting and painting were sources of personal freedom. *I could get off by myself and do these things. But I didn't show them so much. I just did it and gave them away—mostly piecing quilts and painting, and such as that. I gave paintings to all my kinfolk and some of his kinfolk, and gave quilts to all my nieces and nephews. I could get off by myself and use these colors and these beautiful pieces of material and weave them into something that satisfied me. I couldn't wear them, but I could still make them and give them away to somebody.*

Martha Mitchell's artistic pursuits were an increasingly important part of her life after both her son and her husband were gone. Her son, DuWayne, a medical doctor, died of a stroke in 1981 at the age of fifty-six, and his father died six months later at eighty-seven. Still, Martha took a positive view of life. She delighted in her grandchildren, who visited her frequently, and her neighbors and relatives were a constant source of support. "I don't grieve and I don't worry," she told a reporter as they walked along a path in the back yard, looking at the tall pines and the garden. "I'm happy." Late in life Mrs. Mitchell could fully attend to her love of color. What for many years was a talent nurtured but not acknowledged became a creative force in full bloom.

You understand how you can get filled up with creativity and color. I mean you just feel bloomed out with it—and have to do something to show for it that you can actually look at that will explain these feelings, or make other people see how you feel about these things. To keep it all closed up inside of you doesn't do a bit

Martha's creativity is expressed in her adaptation of a pattern she called "Fifty-four, Forty, or Fight." As she explained, "putting the strips in there separated the stars. When I took the strips out, it drew those stars together, forming a complete star." The completed quilt is shown on page 27. Drawings by Martha Mitchell.

of good for me. I have to get it out. I feel sorry for people who can't just let it flow—and go. It's like a stream, a brook babbling along. It has to go.

Martha Alma Martin's introduction to the art of quilting was a very practical matter. *All girls were expected to have eight quilts and four pillows before they married, so they started early on their hope chests. I started at nine years of age. My first quilt was made out of old scraps because my mother was afraid to start me on some of her nice calico, colored pieces that she had for her own quilts. It was a "Nine Patch" that I sewed together, and I'm telling you it was a sight to behold when I got through with it. I think that quilt wound up with my father using it for a pallet out in the yard during his noon naps, but she did teach me how to piece the quilt, and how to make ten stitches to the inch . . . so I started out at that time on my hope chest for the time I might get married. The pillows were made out of goose feathers. We had our own geese. We plucked the down from their breasts and saved it up until we got enough for the pillows. And we had to have one featherbed. That took many a goose feather to make the featherbed and the four pillows.*

Martha's earliest memories were of her mother piecing patchwork quilt tops by kerosene lamplight.

We would use all the scraps from our dresses and our underclothes, and my father's shirts. She made all my father's shirts and all of his pantaloons. I think he had probably one suit that he bought for Sunday wear, but she made all of his everyday clothes.

The extremes to which Mrs. Martin would go to avoid waste of any kind are illustrated in Martha's story of her mother's "string quilts."

Every little bitty scrap was used in those quilts until it got down to where she could not cut a decent pattern out of the scrap, and then she made a "string quilt." Some of the strings were not more than a half inch wide

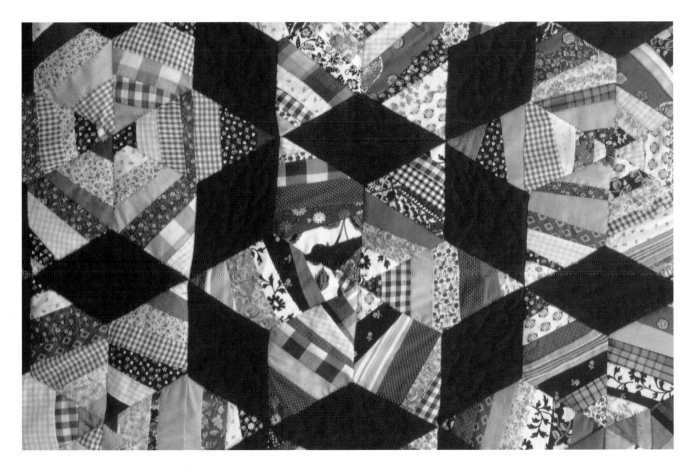

An example of a string quilt.

when she got them all sewed together. She sewed them on pieces of newspaper, cut out in diamond shapes. Some of them were so small that she couldn't sew them together alone, so she sewed them onto the newspaper in diamond shapes, and then she peeled that newspaper off and then sewed the diamonds together, making what she called a "string quilt." All of it was done by hand, mostly at night after the day's work was done and we were sitting around the fireside. She had that box of quilt scraps always sitting by her side. She sat in a little low rocker without any arms on it so that she could move her arms freely. That was my first memory of my mother, sitting there piecing those quilt scraps.

And it was there at her side that Martha, as a tiny girl, began to develop her own talents.

I would get into her scraps and make pictures out of them. I would take a piece of blue, spread it out on a piece of cardboard, maybe fasten it with pins, or some way to hold it down, and then get other colors and cut out trees—and even made skyscrapers. I had never heard of a skyscraper, but I made tall buildings out of black spread out against the skyline with yellow windows, thus forming a picture. I never knew what became of my pictures. I imagine she took the scraps back and put them into her quilts. That was my first art work that I ever did. And that taught me to love the colors of the cloth that she was using. I didn't have any Crayolas or any other color at all except her quilt scraps when I made my first pictures. My father always appreciated those pictures and complimented me on them, and sometimes he would even make a frame for them for the wall, but I don't think she appreciated my using her quilt scraps. We got Crayolas when we started to school. There were only about eight, I think, in the box. If we made other colors we would have to take those Crayolas and mark one color down and then put another color on top of it to change the colors into what we liked, to blend them together. I really took care of those Crayolas. I thought that it was the most wonderful thing I ever saw to have those colors to draw pictures with . . . I learned to love the colors Sometimes when I haven't painted for quite some time, I get loaded with color, just filled up with color.

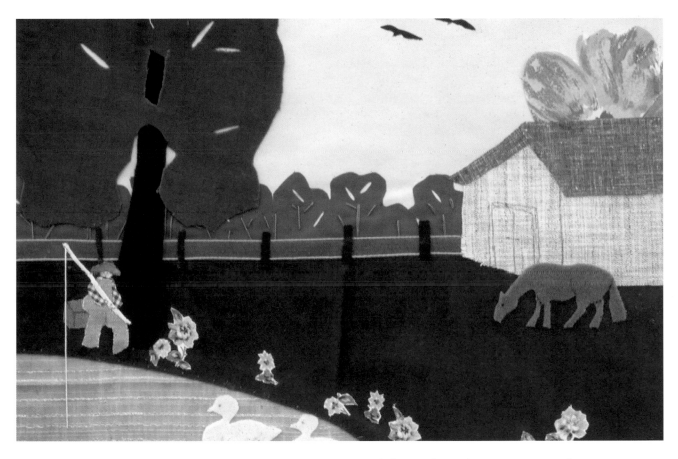

One of Martha's cloth pictures. This particular picture was made by Martha in the 1980s as a sample.

So then I set up a white canvas and begin to wonder what in the world I'll put on it to emphasize those colors, or to get them out of my system

Many of Sarah Martin's quilt tops were constructed of twelve-inch patchwork blocks, pieced together in some traditional pattern from random scraps. "The Rolling Stone" and "Turkey Tracks" were favorites. When she accumulated a sufficient number of the pieced blocks, she would set them together with alternating blocks of solid color calico bought from the store, or join the pieced blocks with two-inch strips of the solid color. The lining, or the bottom of the quilt, was made of unbleached domestic. Goose feathers were used to stuff pillows and featherbeds, but cotton or wool was used as batting in the quilts, placed between the pieced top and the lining. "The batts were made from carded cotton and wool," Martha remembered.

We had sheep on the farm. My mother had two "cards," as she called them. They were rectangular pieces of wood and had stiff bristles on them. She put one in one hand and one in the other, and she would comb that cotton or wool until it was real fluffy and soft and put that into the quilts.

The pieced top, the batting, and the lining, all basted together, were stretched onto wooden quilting frames, ready for the quilting process, the hand stitchery that holds the layers of the quilt together. Mrs. Martin taught her girls to do neat, meticulous work.

Among traditionalists, the tiny, even stitches, ten stitches to the inch, are the mark of a good quilter. Mrs. Mitchell explained: *I have heard so many people say, "I saw a beautiful quilt, and I went to look at it, and when I looked at that quilting, it just lost all its value. It just wasn't pretty anymore." The quilting wasn't good; it wasn't up to par. The stitches were too long, just basted in there *

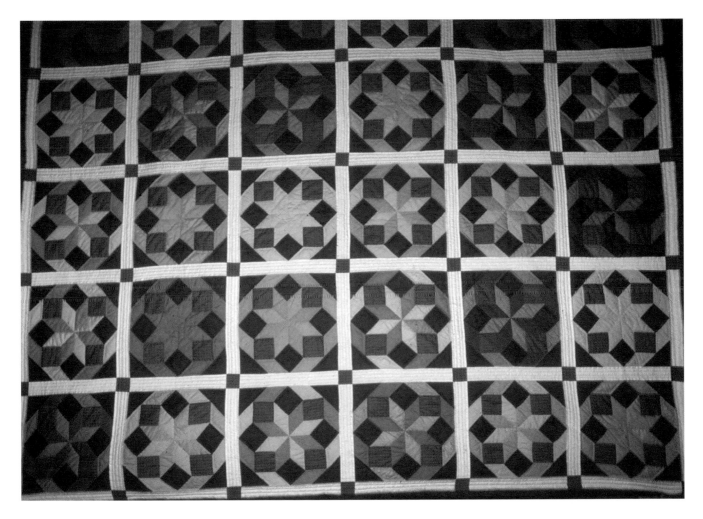

"The Rolling Stone"

When Sarah Martin's daughters didn't make their stitching right, she made them rip it out and do it over. So it was through her mother that Martha developed proficiency in the basic skills of quilting, with all of the hard work, attention to detail, care and concern that it entails. For all her attention to detail, Mrs. Martin was not imaginative in her stitchery. "She didn't go into any intricate designs like I do," Martha explained.

Most always she just followed the piece. They did "fans" quite a lot in those days, just something to hold the top and the batt and the lining together. After she got her tops pieced, then she would put them together and just quilt fans all over which destroyed the pattern to me. It destroyed the harmony of the pieced pattern.

Martha Mitchell recalled her father making trips to the store under harsh weather conditions to trade butter and eggs for the needed supplies for her mother's quiltmaking.

My mother would run out of her calico. The elderly people called it "caliker," but it was really calico. It was always in the dead of winter, and ice and snow were all over the place; you could hardly walk from one building to the other. And he would bundle up in his leggings and muffler and fur cap, and sweater and coat on top of that. And gloves on, and mittens on, on top of the gloves, and take a basket of eggs and butter to the store, which was eight miles away. It was too cold and too bad to get out any of the animals to walk on that ice, but he would gladly go to the store and get her the materials that she needed. She was very emphatic in telling him exactly what to get, and so he would go with his basket of eggs and butter the eight miles. Trudge there and back and bring back what she wanted. Maybe thread, so she could go ahead with her piecing. He wouldn't have done that for anybody else, except the family.

When Martha was a child, the only available fabrics were cotton, linen, and wool.

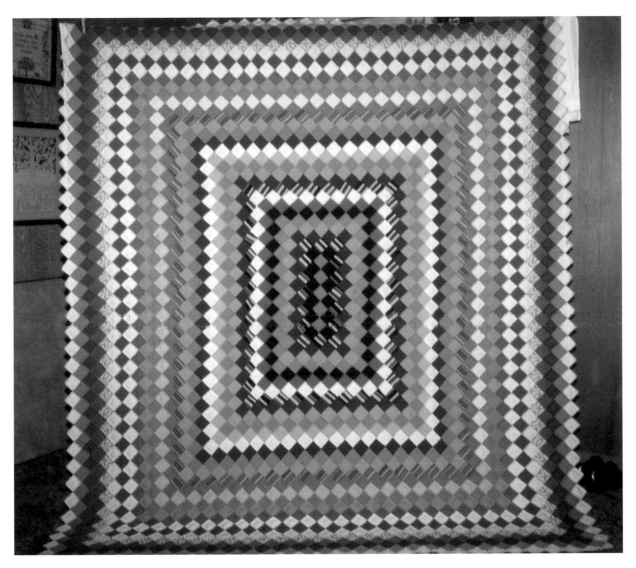

"Trip Around the World"

Calico was ten cents a yard. I remember that well. They had something called "domestic" and unbleached domestic that was cheaper than that. The sheets were made out of bleached domestic, and other things, tea towels and things like that, were made out of unbleached domestic. Everything was cotton. There were no synthetic materials at all. The only thing they had was linen, wool, and cotton. The linen was made out of flax, that could be grown in the yard. But we had gone past spinning the thread. My ancestors did raise the flax and spun the linen out of that. And they had the sheep and they spun the woolens out of that to make the blankets and things. There was a cloth called "linsey-woolsey" in which they mixed the flax—linen thread—and the wool. And they could use the linsey woolsey to make blankets and spreads and counterpanes and underwear and such as that. We bought our thread already made, and it was not very expensive. I think it was possibly a nickel a spool.

In addition to the strictly utilitarian value of quiltmaking, there was the social value. *We had these bees where the neighbors would come out and quilt. That was sort of a social event. The men would be working out in the field, helping with the reaping of the hay, gathering up the corn, or doing farm chores, and the women would come in and quilt. During the meal everybody would gather in . . . it created a social affair more than anything else. Of course, at that time there wasn't anything that you could go to, or any television—everything was done in the home. And so, when it got time to invite the neighbors in, we'd have a quilt in the frame, and we would quilt while we chattered and gossiped. Most always everybody would bring some kind of dish for the dinner, and then the men would gather in from the fields for the noon meal. Church and the home was the center of all social events.*

Bouncing a cat on the finished quilt is a custom that Martha recalled. *It was always my kitten. They put the poor little thing in the middle and then everybody would gather around the edge and shake it, and the poor little thing was scared to death and it would run off toward somebody. And that person would be the*

Mrs. Mitchell considered briar stitching as her trademark. On the back of a quilt the edge of the top was whip-stitched to the lining. Then she covered the seam with the embroidered briar stitching.

"Arabian Tents"
Page 73 details the lining and a full view of the quilt.

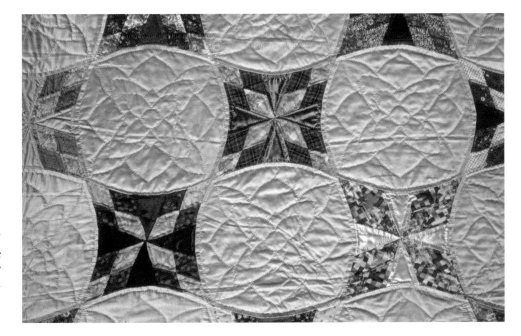

next one to get married. And of course, everybody would try to shake it toward a certain person. Another tradition is that when you're quilting, never just leave your needle just lying out loose. Always put another stitch on the needle before you get up and leave it . . . so you'll have the next day's work started.

Martha's brother, the only boy in a family with three girls, never developed an appreciation for quiltmaking.

He didn't think much of quilting, because when my mother would have a quilt spread out to quilt it, he wanted her to play with him. He was the only boy. He would get up under that quilt and put his head against it and shake it. She would take the scissors, or the thimble or something and pop him on the head and make him get out from under the quilt. So he kind of fell out with quilting because my mother wouldn't play with him.

Working on quilts with her mother, Martha learned more than simple stitchery.

As we cut and pieced, my mother . . . taught me things she was taught when she was a little girl . . . how to be a gentlewoman, how to become a good housekeeper, how to be a good mother, things a boy could do and a girl should not; these things she taught me as she had been taught herself, just as she followed the traditional quilt patterns as they had been handed down for generations, pieced from the scraps on hand, put together with solid squares or strips. She never veered from the patterns that had been told to her. "Idle hands are the Devil's workshop," she would tell me, so as a girl I must keep my hands busy. "Before a girl can get married she must have on hand in her hope chest eight handmade quilts, a featherbed and four down pillows!" It seemed such a load for an eight-year-old girl to shoulder.

But Martha's attitude was soon to change.

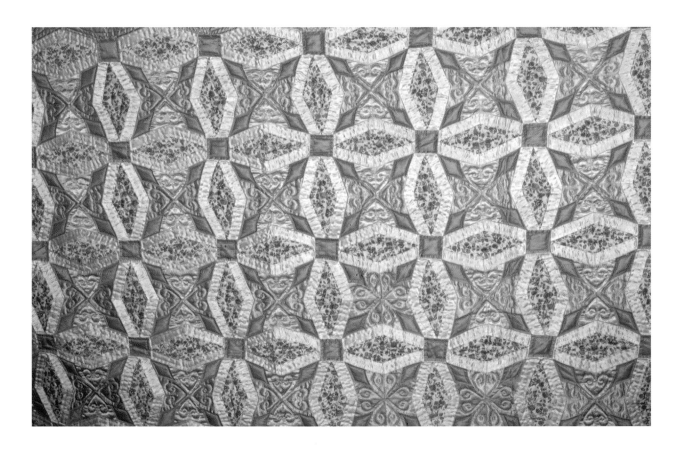

"Primrose"

At the age of nine years I had my first boyfriend. It was so complimentary to be courted by an older "man";

he was eleven and two grades ahead of me in that little one-room schoolhouse. So I thought I should get busy

or I would have to become a maiden lady for the rest of my life. I lost that boyfriend in passing years. I do not

even remember his name, but I can recall his appearance even now, sort of on the chubby side and his face

completely covered with freckles. He was a very handsome man to me, and he started me on my quilting

career.

IDEAS OF HER OWN

Martha Alma Martin learned her lessons well, mastering the quilting skills that her mother taught her, but from the beginning she developed ideas that were her own. Her modifications of traditional patterns, colors, and materials resulted in quilts that are a far cry from the utilitarian patchwork of her mother's generation. The control of color in patchwork designs was one of Martha's first conscious modifications of the tradition:

I saw my mother just picking up anything to save the scraps and put them into blocks, and I just wondered

why they couldn't be—with all the work she put into them—why it couldn't be made prettier by using the

same colors in every block. But she didn't have the same colors; she just used what scraps she had, and

sometimes they didn't harmonize at all—which rather upset me because that didn't appeal to me at all—

just using anything. Of course, economically, that was the thing to do. And they were used only for covers

anyway, and not for ornament, so it really didn't matter. But she did put so much work into those, and I just

wondered why it couldn't be used to better advantage, to make something more beautiful than just something to sleep under.

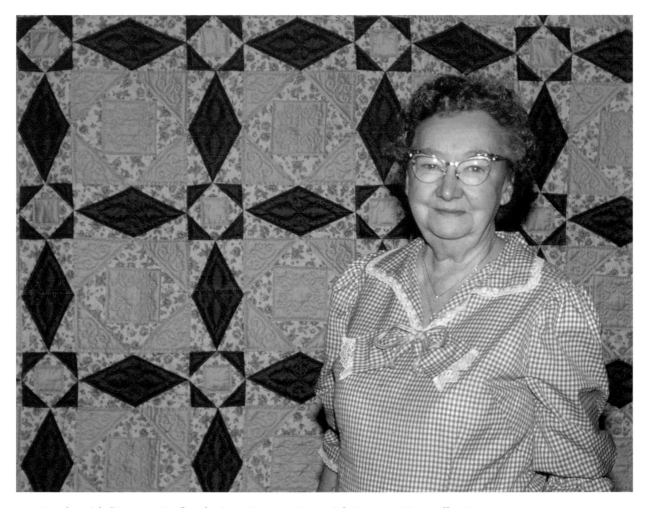

Martha with "Storm at Sea" at the Sam Houston Memorial Museum, Huntsville, Texas.

After she was financially able, the "scraps" that Martha Mitchell pieced together were often cut from whole new cloth, and the fabrics included velvet, satin, and crepe, as well as the sateens and calico.

The colors that Mrs. Mitchell selected for the fabrics that went into the quilt top are frequently related to the nature of the patchwork pattern. For example, she chose shades of blue for "Storm at Sea" because she always associated blue with the sea. For "Medley of Windmills" she chose bright colors, emphasizing red and green. "I just know how I want it to look," she said.

In the "Love Knot," I wouldn't think about using anything for the wedding rings except gold. A lot of times somebody will have a color scheme that they want me to use, if I make one to order—which I don't like to do much; I'd rather do my own—but if somebody wants a quilt and they tell me that they particularly want their room in blue, or red, or whatever . . . I would select a pattern, if they haven't already selected a pattern, that would suit those particular colors.

In addition to the control of color and fabric, Mrs. Mitchell's individual creativity can be seen in other ways. Martha frequently departed from her mother's tradition by eliminating the solid colored strips or alternating solid colored blocks ordinarily used to join the pieced blocks. In a traditional quilt, the strips or solid blocks serve at least three functions. First, in a pieced top made up primarily of random scraps, strips of blocks of a single color give a sense of unity to the overall design. Additionally, use of the solid sections reduces the amount of piecing necessary to complete a quilt top, and finally, it disguises inexactness in the composition of the pieced blocks. Omitting these strips and blocks necessitates extreme accuracy in making all the pieced blocks identical. By eliminating the joining strips and controlling the colors, Mrs. Mitchell could bring the blocks together, increasing the complexity of the overall geometric patterns, creating designs not present otherwise. The quilt

"Medley of Windmills"

top becomes a single mass of interlocking designs, and the inexperienced eye finds it difficult to discern where one pieced block ends and another begins.

The quilt that Mrs. Mitchell named "A Medley of Windmills" was constructed by eliminating the strips usually used to join the pieced blocks of the "Arkansas Traveler" pattern. The resulting interlocking design includes two distinct windmill patterns that are recurrent.

Mrs. Mitchell offered a unique explanation of her adaptation of a pattern she identified as "Fifty-four, Forty, or Fight," shown on page 27.

Putting the strips in there separated the stars. When I took the strips out, it drew those stars together, forming a complete star. It was red, white, and blue originally, and after I had put it together, it seemed to me more like a flag.

Her adaptation of a relatively simple "Four Point Star" block pattern, shown on page 75, is complex. Eliminating the straight strips between the square pieced blocks produced large diamond shapes. Then she added strips to outline the diamonds. A result is her "Primrose" quilt, shown on page 57, in shades of lavender and white sateen, a repetition of a pattern that she evolved for "Green Gables," her green and rose quilt that took top honors at the State Fair of Texas in 1970.

Another characteristic of Mitchell quilts is seen in the borders she frequently invented to frame the quilt. Sometimes a border might result from the very practical need to enlarge an heirloom pieced top to make it suitable for a large bed, but border making always provided opportunity for individual creativity: in making new patchwork designs to complement the central quilt, and always in exploiting the added open spaces as show places for original stitchery.

"Double Wedding Ring" family heirloom was quilted for Mayenell and Melvin Mason.

Exquisite stitchery is the most distinctive aspect of Martha Mitchell's work. Often original in design, it was lavished on everything she made. The solid colored lining of a Martha Mitchell quilt is often as impressive as the top because it shows off the virtuosity of her stitchery and the elaborate nature of the quilting. The practical purpose of quilting is merely to hold together the three layers: the top, the batting, and the lining. A quiltmaker can meet that basic requirement with widely spaced rows of stitching, either straight or fanned, but the quilter whose craft becomes art is more likely to create detailed patterns that follow and/or compliment the patterns of the quilt top. "A pieced top to me is absolutely lifeless . . . , " Mrs. Mitchell said.

It's the quilting that brings it out and brings it to life. For instance, you can take just a very plain design, something maybe just sewed together in squares, and put pretty quilting on it, and it makes an altogether different outlook on the whole thing.

Her complex and imaginative approach to quilting was demonstrated on pieced tops that other people brought to her, family heirlooms from earlier generations. For "Double Wedding Ring" or "Dresden Plate" she stitched around each small piece in the pattern, one-fourth inch inside the edge, and then filled all the large open spaces with an original design. On her own "Rob Peter to Pay Paul," she spent five hundred hours on the quilting alone. For the border on a gold and white satin "Blazing Star," she quilted vines, leaves, and stars, all original patterns. "I put stars around it because the pieced block had stars in it."

Commenting further on her inspiration for quilting designs, Mrs. Mitchell explained: *Some of them are traditional designs that I modified, and some of them I just invent myself to fit the space that I have and to complement the pieced block. Some of them . . . maybe I have seen a pattern somewhere. I don't look at*

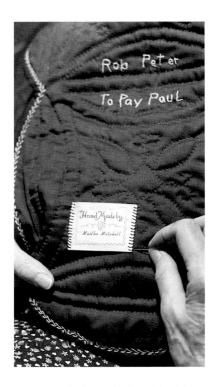

Martha's professional looking,
factory-made label. The
embroidered briar stitching
that covers the whipstitching
joining edges of lining and top
is considered Mrs. Mitchell's
"trademark."

Quilting for "Rob Peter to Pay
Paul" took five hundred hours
on the quilting alone.

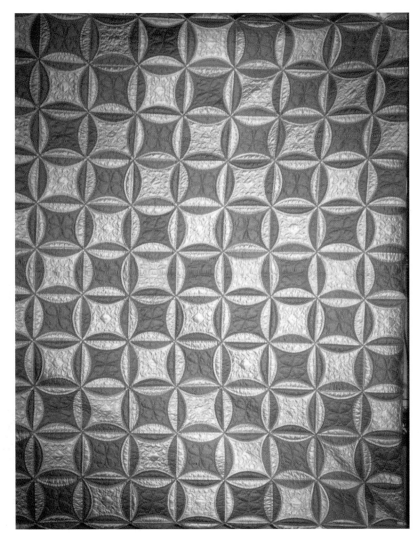

a book or anything, but I have seen a pattern somewhere, and I think that if I make that a little bit different, it will look better than the traditional design would look. I rarely ever make them like somebody else has made them.

Most of the details that make Mitchell quilts different from those of others are seen in her finishing touches. To hem a quilt, she folded the edge of the top over onto the back, sewing it down with a whip-stitch. Then she covered that sewing with embroidered briar stitching in contrasting color, an attractive finishing touch that she considered her "trademark." Finally, if she had been responsible for the entire quilt, including the pieced top, she added a professional looking, factory-made cloth label. It read "Hand Made by Martha Mitchell." On some quilts, using embroidery stitching, she might add other identifications such as the name of the quilt, the date, her own name, or the "signature" that she usually placed on her paintings, "M Mitchell" with interlocking M's.

Although Mrs. Mitchell's completed patchwork quilts have many unique qualities, the process of making them was similar to that of other quiltmakers. First, she selected or invented a pattern and made her overall plan, determining colors and selecting appropriate materials. Using lightweight cardboard patterns, she cut out the small pieces of fabric that form the blocks. Some quilters insist on doing all hand work; however, Mrs. Mitchell used a sewing machine to piece the blocks because the machine work is stronger than hand stitchery and it will not even show in the finished quilt. When the required number of blocks had been completed, she set them together with any other elements that she was including, such as borders or joining strips and blocks. Pieced "blocks" are not always squares. For instance, the blocks for "Double Wedding Ring" are ellipses, but they give the effect of interlocking rings when they are set together with sections of solid color. The process described for completing the top applies to patchwork, but it will vary with other forms such as applique.

Cutting a cardboard pattern.

Tracing the cardboard pattern to the fabric.

Martha working on "Double Wedding Ring." Blocks for the quilt are ellipses, but they give the effect of interlocking rings when they are set together with sections of solid color.

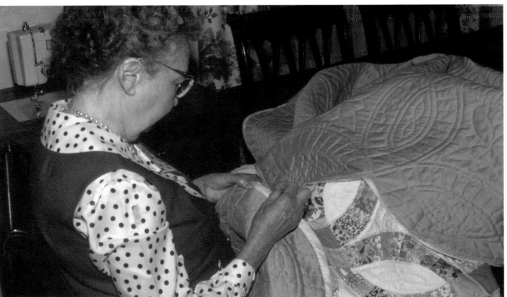

On the surface of the finished top, Mrs. Mitchell drew the quilting designs that she would later stitch.

First I draw the pattern on a piece of cardboard. Then I painstakingly cut it out so that I can mark around it with a pencil. I take a light lead pencil and very delicately trace around each leaf and each scallop, each pattern that I've cut out. This doesn't show after it's been quilted and the thread pulled tight

In making the cardboard patterns or templates, Mrs. Mitchell sketched freehand. She never traced a pattern directly from a book.

The lining was prepared, usually a solid color, by sewing together thirty-six-inch or forty-eight-inch widths of fabric. This lining was then stretched onto the quilting frames. The frames were hand-made from sturdy pieces of 1" x 2" pine with strips of heavy cloth tacked along the edge. Some of these frames were made by her husband, and some were made by her nephew Edward. 1 x 2's are held together at the corners by bolts, and there are several holes drilled at the end of each piece so that the size of the frame can be adjusted. The sides of the quilt lining were basted onto the cloth strips on the frame, and the frame expanded as needed to stretch the lining tight and smooth. Next, the batting and the top were basted onto the lining.

Instead of the traditional cotton batting, Mrs. Mitchell used the same polyester that most other quilters use today. "Cotton will press down and it doesn't spring back up after the quilt has been folded up for quite some time," she explained

The cotton becomes flat while the polyester will come back up and be puffy as it was originally intended Another thing is that you can use a little thicker batt in the polyester than you can in the cotton, because it's easier to quilt through. The cotton is rather hard, and if it gets a bit damp, the needle will hardly go through it.

Stretching the lining.

Adding the batting.

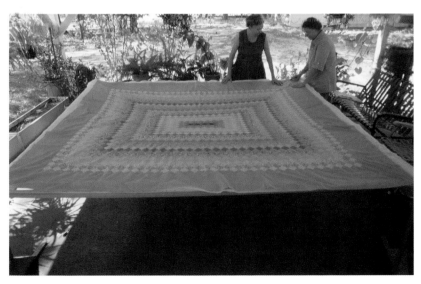

Pinning the quilt top to the lining and batting.

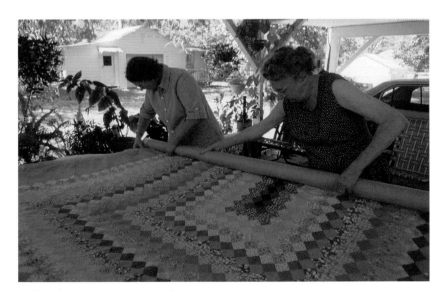

Rolling layers to create a reach.

After this "sandwich" of top, batting, and lining were basted together and stretched to the fullest on the frame it was rolled up scroll-fashion so that only about a two-foot section was left exposed. This is called a "reach," the width that a quilter working alone can comfortably manage. End pieces of the frame were replaced with shorter ones. For group work, larger sections of the quilt would be left exposed. Mrs. Mitchell accomplished this task of "putting in" the quilt on her covered patio with the help of a friend, but she moved indoors for the long hours of quilting. The frame was supported by the dining room table and chairs.

Mrs. Mitchell preferred to work alone because the skills of others did not match hers.

. . . I don't want anybody else quilting on my quilts. They don't quilt well enough. That's it, pure and simple. I would be glad to have somebody come in; I would enjoy the society of other women. I have had other women say, "Let me know when you have a quilt in the frame and I'll come out and help you" but there's not anybody who could quilt well enough that I could let them quilt with me. I don't mean to sound snobbish or anything, but they just don't.

The needles used were short and stubby, called "Between Tens," and the quilting thread could be all cotton or "superstrength" polyester. A thimble is essential for the process. Working from the top of the quilt, she guided the needle with thumb and forefinger, pushing it through the fabric with the thimble-covered index finger, making four or five tiny stitches at one time. The left hand stayed beneath the quilt to guide the needle back up. Mrs. Mitchell's left fingers sometimes became irritated, but it was necessary to feel the needle point in order to be sure that it came all the way through. As a section was completed, it was rolled up and another "reach" was exposed. "There is a rhythm in quilting," she said.

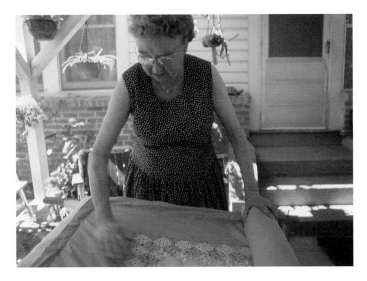

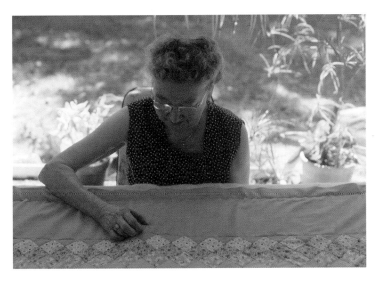

Martha creates her reach.

The first stitches begin.

You stop a minute and here you go again. Your hand is keeping time. If you don't get that rhythm you can't make your stitches . . . it takes a great deal of practice.

After the quilting process was complete, the frame was removed and the quilt was ready to hem. The list of Martha's quilts goes on and on: "The Golden Shield," "Mariner's Compass," "Dove in the Window," "Four Hands Around." Once she counted up to a hundred quilts and then lost track. They were always based in tradition, but there were always the distinguishing features that bear the mark of her compulsion to modify, elaborate, invent, and embellish.

One of her last projects, a *tour de force* she called "Arabian Tents," brought together all of the Mitchell practices that made her work an art. She modified a traditional blocked pattern; she controlled color precisely; she provided an unusual mode for setting the pieced blocks together with sections of solid color; she made a border "frame"; and she indulged in extravagant stitchery.

"Arabian tents" is an adaptation of a pattern she found in a magazine fifty years ago. Each of the thirty-two pieced "tents" that cover the quilt top has its own color scheme. The pieced "tents" are identical in design, but no two are alike in color. In contrast, the open spaces made of solid tan fabric are quilted to suggest sand dunes that surround the tents, and the border of blue-green represents the oasis. In the original magazine pattern, each pieced block was filled in at the sides with the solid-colored fabric so that the block would be a square. Then the pieced squares were set together with solid-colored squares. Always the innovator, Mrs. Mitchell left her pieced blocks with concave sides and then cut the alternating solid-colored blocks with convex sides. The finished top blends together with a greater sense of unity, because she eliminated seams within the solid-colored areas. Each solid area, then, became a showplace for elaborate stitchery in the final quilting.

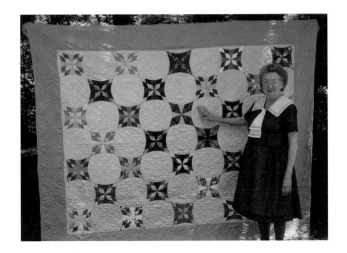

"Arabian Tents"

"Arabian Tents" lining

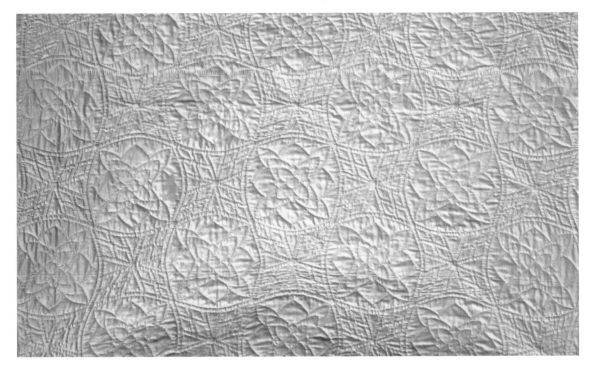

TRADITION AND INNOVATION

Over thirty years ago, the late Mance Lipscomb, Navasota blues singer, was asked, "Mance, those songs you sing don't always come out the same way, do they?" "No," he replied, "you leave off and add to." The same observation may be applied to Martha Mitchell's quiltmaking as we observe the transformation of folk tradition in her work. Martha Mitchell was forever "leaving off" and "adding to." She never invented a totally new patchwork pattern, but she never seemed content to complete a quilt without some modification of her own. Even the pieced tops that she quilted for others often became raw material for the creative process as she satisfied her inclination for elaboration and embellishment.

As with any traditional artist, Mrs. Mitchell was indebted to her heritage, to those who taught her basic skills and gave her ideas for adaptation. Like other artists who work within the folk tradition, she forged a link between past and future generations. Even as she admitted that she did not "want anybody else working on my quilts," she was constantly giving help to others, especially to those women who were learning and practicing the needlecrafts that she knew so well.

Of all the influences on her own work, Martha looked to her mother as her original inspiration and guide.

I think my mother was really a poetess. She could feel the seasons and the wind and the storms in her, but she couldn't express herself. Maybe that's the reason she pieced quilts. Or maybe it was because women were not supposed to express themselves. I can see her now standing out on the porch and the wind blowing on her. And she could feel that as something wonderful. The sun coming up—you could just see it in her face; she just loved those things. But she never put it into words. Mainly, I guess, just because women weren't supposed to do that. She was a religious woman. She read her Bible. I have her bible now; it's all torn to

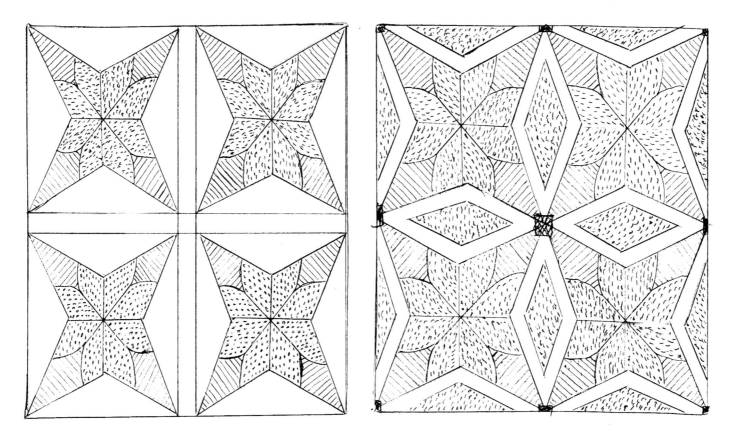

Martha's adaptations of a relatively simple "Four Point Star" block pattern is complex. Eliminating the straight strips between the square pieced blocks produced large diamond shapes. She then added strips to outline the diamonds. The result is her pattern "Primrose," shown on page 57. Drawings by Martha Mitchell.

pieces where she used it so much. She read that and tried to follow it—all the scriptures. I don't do that so much as she did because, well, to be a good woman you were supposed to be calm, and don't get upset over anything, and whatever the husband said, that was what you were supposed to do. Keep him comfortable and wait on the children. But I sometimes make my own rules. I feel if you follow the Ten Commandments, and don't break any of the Ten Commandments, you've done pretty well.

Sarah Martin may not have expressed herself in words, but her daughter once wrote a tribute in verse called "My Mother's Hands," which was published in the *Henderson Gleaner* newspaper in Kentucky in the 1920s. It read, in part:

> Wrinkled and gnarled to others they seem, Yet in truth so tender and kind;
>
> The most beautiful hands are the best ever yet
>
> Are the hands of that mother of mine.

Martha's own hands were softly beautiful, and to watch them in action at the quilting frame was to see the rare grace and acuity of an artist's hands: fingers that made the rapid, flexing movements necessary to take as many as five stitches on the needle at a time.

Martha Mitchell's quilting provides an eloquent basis for understanding the relationship between craft and art, and the ties between tradition and creativity. The critic's tendency to radically separate the two is borne out as a false distinction, if we understand that for Mrs. Mitchell tradition was the well-prepared ground out of which blossoms of imagination and creativity spring. Tradition and creativity co-mingled inseparably in her art because both together enabled her to express a sense of endurance and integrity which is no less a sense of love: "Quilts are so much warmer than blankets," she said.

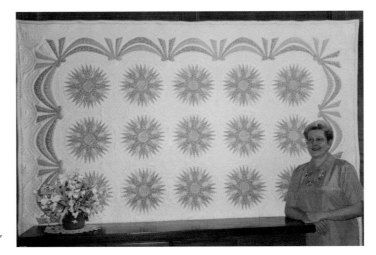

"Mariner's Compass"

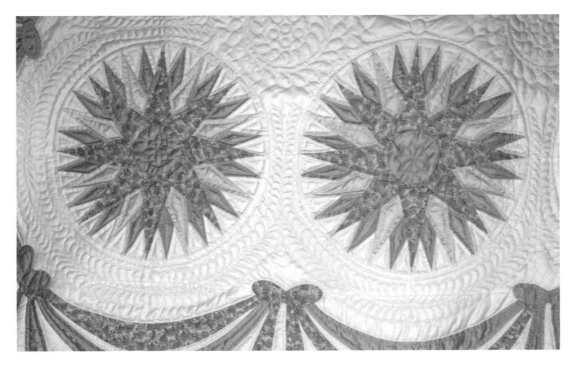

Because every stitch is a loving stitch, and that warmth stays in there. There's something about quilting. If you are tired, you can sit down and quilt a little bit, and that all passes away. If you are angry, you can sit down and get into that rhythm of quilting, and all that anger just passes away

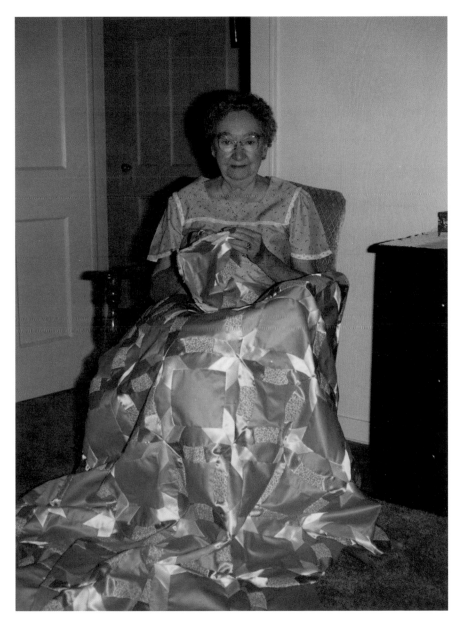

Martha holding the
pieced top of her
final quilt,
"The Love Knot."

AUTHOR'S NOTE

With a few exceptions, direct quotations from Martha Mitchell are extracts from my tape-recorded conversations with her at her home in Huntsville, Texas, May 11 and July 10, 1982, and August 30, 1983. I followed Mrs. Mitchell's work closely, beginning in 1981 and continuing until her death in 1985. Mrs. Mitchell's comments on the renaming of Possum Walk Road, on the "Mitchell Diggin's," and on drawing quilting designs on pieced tops, are taken from a sound tape she made for a 35mm slide presentation I produced for initial showing at the annual meeting of the Texas Folklore Society, Fredericksburg, April 9, 1982: "Martha Mitchell of Possum Walk Road: Artist with Needle, and Brush." "I don't grieve and I don't worry . . . " is quoted by Jennifer Harvey in "Huntsville Celebrity," *The Huntsville Item*, Sunday, July 17, 1983, p. 1C.

REFERENCES

Cooper, Patricia and Norma Bradley Buferd. *The Ouilters: Women and Domestic Art*. Garden City: Anchor/Doubleday, 1978.

Mainardi, Patricia. "Quilts: The, Great American Art." In *Feminism and Art History*, edited by Norma Brunde and Mary D. Garrard, pp. 330-46. New York: Harper and Row, 1982.